POWER OF THE WORD

Essays by
Chang Tsong-zung, Guest Curator
Robert Lord

INDEPENDENT CURATORS INTERNATIONAL, NEW YORK

Published to accompany the traveling exhibition *Power of the Word*, organized and circulated by Independent Curators International (ICI), New York. Guest curator of the exhibition is Chang Tsong-zung.

Power of the Word was funded, in part, by grants from The Foundation-To-Life and .

EXHIBITION ITINERARY

TAIWAN MUSEUM OF ART
Taichung, Taiwan
May 22–August 29, 1999

FAULCONER GALLERY, GRINNELL COLLEGE
Grinnell, Iowa
October 6–December 3, 2000

EMERSON GALLERY, HAMILTON COLLEGE
Clinton, New York
January 30–March 30, 2001

UNIVERSITY OF ARIZONA MUSEUM OF ART
Tucson, Arizona
July 29–September 23, 2001

TANG TEACHING MUSEUM AND ART GALLERY, SKIDMORE COLLEGE
Saratoga Springs, New York
October 13, 2001–January 6, 2002

© 2001 INDEPENDENT CURATORS INTERNATIONAL

799 Broadway, Suite 205
New York, NY 10003
Tel: 212-254-8200 Fax: 212-477-4781
www.ici-exhibitions.org

LIBRARY OF CONGRESS CATALOG NUMBER: 2001092098

ISBN: 0-916365-62-X

EDITORS
Stephen Robert Frankel (Robert Lord Essay)
Laura Morris (all other texts)

DESIGN
Purtill Family Business

PRINTING
Direct Printing, Hong Kong

PHOTOS
Courtesy of Chang Tsong-zung, Roy Lee
Qiu Zhijie, Eric Otto Wear and Yan Shancun

COVER
Xu Bing, *Clay Words*, 1993 (detail)

INSIDE FRONT AND BACK COVER
Qiu Zhijie, *Coping One Thousand Times*
"Preface to Orchid Pavillion", 1995-1996 (details)

TABLE OF CONTENTS

FOREWORD AND ACKNOWLEDGMENTS
by Judith Olch Richards

Independent Curators International (ICI) is dedicated to creating traveling exhibitions of contemporary art of national and international importance that give wide audiences the chance to see and learn about a broad range of recent artistic developments and aesthetic concerns. With this exhibition, ICI is presenting for the first time in its twenty-five year history, an aspect of the compelling work being done today by Chinese artists.

Power of the Word offers a focused look at significant and provocative works in a wide range of mediums by nine Chinese artists who both celebrate and critique the conventions and powerful traditions of the written word in China. Breaking with the 2,000-year-old traditions of Chinese calligraphic art, these artists reassess the aesthetic and cultural assumptions of China's word-based society. Their permutations of calligraphy reflect a fresh understanding of the relationship between language and art, often stimulated by interaction with Western Culture.

Power of the Word and this accompanying catalogue have been made possible through the dedication, skills and generosity of many individuals. First and foremost, I extend warmest thanks and appreciation to the exhibition's curator Chang Tsong-zung who has worked with great diligence, enthusiasm, generosity, and good humor on the development of this exhibition, and whose thoughtful catalogue text brings us much closer to the works. My gratitude also goes to Robert Lord for his articulate and insightful essay that enriches and expands our understanding of the place that calligraphy holds in Chinese culture and the visual arts. Special thanks are due as well to the artists whose work we are presenting, for their gracious cooperation and enthusiastic support for this project.

It is a pleasure to convey sincere thanks to the sponsors of this exhibition. I am extremely grateful to both the Foundation-To-Life, Inc., and the National Endowment for the Arts for their generous contributions without which this project could not have been realized.

Given the unique nature of ICI as a museum without walls, each of our exhibitions is created through an extensive collaboration between a guest curator and the ICI staff, and then comes to life when presented at each venue of its tour.

Power of the Word has benefited tremendously from the professional skills, dedication and enthusiasm of the staffs at each of its venues. I therefore wish to thank the following museum directors for their institutions' important contributions to the project through installation designs, printed materials and public programming that enable their audiences to better understand and appreciate the visual and conceptual aspects of the works on view: Ni Tsai Chin, Taiwan Museum of Art, Taichung; Lesley Wright, Faulconer Gallery, Grinnell College, Iowa; Bill Salzillo, Emerson Gallery, Hamilton College, Clinton, NY; Charles Guerin, University of Arizona Museum of Art, Tucson; and Charles Stainback, Tang Teaching Museum and Art Gallery, Skidmore College, Saratoga Springs, NY.

My appreciation and thanks also go to ICI's staff for their work on this project, particularly Carin Kuoni, director of exhibitions; Jack Coyle, registrar; and Jane Simon, exhibitions assistant. Special thanks to intern Judi Caron for coordinating the production of this publication. My appreciation also goes to Hedy Roma, director of development; Colleen Egan, development associate; Eileen Choi, development assistant; Sarah Andress, exhibitions assistant; and Sue Scott, executive assistant and press coordinator. In addition, I want to recognize the important assistance to this project received from the staff of Hanart TZ Gallery in Hong Kong and Hanart (Taipei) Gallery, especially Joanne Huang and Marcello Kwan. Finally, it was a pleasure to work with the Purtill Family Business on the design of this publication, and to benefit from copy editing by Laura Morris for Chang Tsong-zung's text and Stephen Robert Frankel for Robert Lord's essay.

On behalf of ICI's Board of Trustees, I express deepest appreciation to everyone who has contributed so generously to make this exhibition and catalogue possible.

—Judith Olch Richards, Executive Director

POWER OF THE WORD
by Chang Tsong-zung

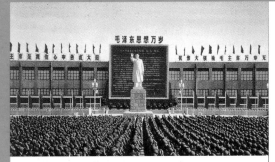

Statue of Mao and Slogans in front of a military building, 1967

In China, the art of the written word has traditionally been accorded a preeminent position among the visual arts. Calligraphic works by famous writers, in both original and copies engraved on stone, have always been embraced as the greatest artistic treasures. In the eighth century, an emperor of the Tang dynasty acclaimed calligraphy as one of the "three perfections" worthy of a gentleman scholar, the other two being poetry and painting. Until the early twentieth century, Chinese literati considered etymology the foundation of learning, revering the written word as the "root of the Classics, and the source of virtuous politics" (from the preface to

Shuo Wen Jie Zhi, dictionary from the 2nd century). Within the visual world of traditional Chinese society, we find that the written word is dominant as a decorative art form, and its applications quite varied.

VISUAL CULTURE AND VISUAL LANGUAGE OF POWER

Imagine looking at an average Chinese town at the turn of the twentieth century, before the end of imperial rule. Whether entering from city gates, walking around the streets or taking detours into side alleys and private gardens, we would find calligraphic inscriptions as among the key elements of architectural decoration. Carved into wood or set into the architecture in brick or stone, calligraphy would appear centrally over the city gates, on beams and pillars of civic and religious buildings, and as poetic decoration in residential and garden architecture. By contrast, a European city of equivalent significance from the same period would have had—instead of the ubiquitous poetic writing—figurative art, such as statues and paintings dominating civic and private buildings.

Special note should be taken of the different approaches to the visual language of power between European and Chinese visual cultures. The European tradition tends to monumentalize heroes and leaders in public sculptures, whereas in China this was a rare practice. A public commemorative monument would have been dominated by calligraphic writing, an aphorism sometimes accompanied by a short essay, usually cut in stone. In other words, if it had been the Chinese who had their say in Rome, the equestrian statue of Marcus

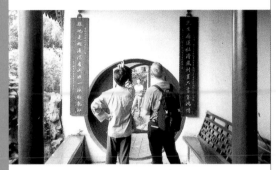

Covered passage in a garden

Aurelius on the Capitoline Hill would have been replaced by an inscribed stele sheltered by a pavilion. Throughout the Chinese domain to this day, sacred mountains, historical sites and important temples bear witness to this tradition of political patronage through the calligraphy of emperors and illustrious scholars. The practice of incising commemorative texts on sacred mountains was an ancient custom that started to be widespread from the fifth century B.C., and became an exclusively imperial prerogative in the brief Qin Dynasty (221–208 B.C.). By the Han Dynasty (208 B.C.–220 A.D.), carving texts into the faces of mountains became fashionable and was practiced on many official levels. Famous calligraphic models known through rubbings taken from stone reliefs and revered by present day calligraphers, such as the **Shi-men Sung** and **San-gong Shan** texts, originally commemorated major civic projects in remote regions. These carved texts marked the further outreach of civilisation and political patronage. They reproduced the original calligraphy of their authors, implying that the powers the inscriptions represented were personal, graced with a human presence. This personal dimension of carved calligraphy differs significantly from the standardised, and therefore impersonal, lettering used for stone monuments and buildings in Europe.

Until the Communist revolution in the mid-twentieth century, all historical cities in China were richly abundant in calligraphy by important figures, reproduced as carved plaques in wood or stone. Not only were temples and other public buildings elaborately bedecked with calligraphic inscriptions, even the signs of small shops were often in the handwriting of famous intellectuals. China's traditional visual culture may be called a landscape of the written word. On a social level, these public inscriptions marked a physical presence of diverse cultural and political powers, claiming China's public spaces for politics, education, art, commerce, and entertainment with the help of a poetic and artistic form. With calligraphic writing, civic spaces were being "civilized."

The most revolutionary transformation of China's visual culture of the twentieth century was probably the dramatic rise in status of portraiture in public visual language. This may be interpreted as the radical shift of the visual language of power from the predominance of calligraphic writing to that of figurative portraiture. The history of this shift in the language of power also serves as a barometer of China's cultural transformation, from that based in local tradition to a Western-inspired "modernity." After the Republican Revolution in 1911, political leaders like Yuan Shi-kai (1859–1916) and Sun Yat-Sen (1866–1925) imitated Europeans in having their own portraits promoted as political icons. Placed on coins, stamps and monetary bills, faces of leaders became official emblems in conjunction with the national insignia.

For China's post-imperial leaders, the shift signified the advent of a new, "modern" political culture and power structure. By comparison, as a manifestation of political power, calligraphic writing is a more "cultural" and personal medium; it always involves intellectual content and a personal hand, no matter how politicized and slogan-like the text, (such as Mao Zedong's famous "Serve the People"). The icon, on the other hand, erases cultural associations, presenting the individual as an uncompromising embodiment of power.

The "modernity" of the icon's power was inseparable from the new intellectual authority associated with the figurative nature of portraiture. The modern portrait in China was

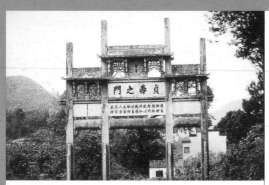
Commemorative arch in Anhui Province, 18th century

based on the style of nineteenth century European academic realism, which was itself a product of the Enlightenment. The spirit of this new academic style advocated the use of a "scientific" method to study and represent the human figure, presenting an "objective" set of measures for painting that usurped the traditional master-apprentice system. The art academy, rather than the traditional "masters," became the new authority on art. Works produced in this spirit reflected a new faith in human rationality, and renewed man's right to dominate the natural world. In China, the realistic portraiture of political leaders implied new power accorded by scientific positivism and celebrated what can be called the new religion of science.

From the rule of Sun Yat-sen to that of Mao Zedong (ruled 1949–1976), the political authority of calligraphic writing and the icon were used in tandem. In the era of Mao, especially during the decade of the Cultural Revolution (1966–1976), the Chinese visual world was dominated by the single icon of Mao. Even in calligraphy, during the 1970s, Mao's style was the most prominent. It adorned every major institutional building and was copied by the faithful nationwide. To this day, Mao's influence on this art remains predominant. In December 1999, a major periodical on calligraphy conducted a poll to determine the ten leading masters of the twentieth century, and Mao was ranked number five. Until 2000, important institutions such as leading universities and major newspapers have continued to use Mao's calligraphic inscription as their logos. Even today, those unfamiliar with the art of calligraphy can still recognize Mao's writing style. As an embodiment of both the power of the word and the icon, Mao symbolized China's transition from a traditional culture into that of a Westernized modern culture.

LITERATI AND MASS CULTURE

Ever since the emperor of the Tang dynasty deemed the scholar Zheng Qian (died 764) to have attained the "three perfections," the Chinese literati have set this as their own artistic goal. The traditional hierarchy of the three perfections places poetry at the top, followed by calligraphy and then painting. Therefore it was customary for literati artists to feign humility by claiming their paintings as inferior to their calligraphy, and their calligraphy inferior to their poetry, which was, of course, bravado in disguise. Since poetry is literature, among the visual arts calligraphy is understood to be sovereign.

Conversely, one can also claim that calligraphy is the one true Chinese popular art. Until recent generations, for over two thousand years, every Chinese who ever learned to read and write practiced calligraphy as an art, even if only marginally. Across the nation, everyone, from village children in the remote countryside to bookkeepers in small market towns, had an idea about what was "good" calligraphy. They were all unwitting participants in the mass movement of calligraphic art in China. Elementary models of calligraphy began with copy-books, sophisticated models included famous texts incised on stelae kept under official care. Both the literati and the common people looked toward the paradigm of the great calligraphers, primarily of the Jin (265–394), Tang (68–907) and Song dynasties (960–1279). In today's ideological language, using terms such as "democracy," "the people" or "the masses," we may comfortably claim that one of the remarkable features about Chinese traditional culture was its "democratic" and "populist" spirit, in that its most revered fine art had an unusually wide popular base, and that this art was simultaneously practiced as a pragmatic tool.

A fine art with such a long history of mass participation is a notable phenomenon. Calligraphy with its position above painting also reflects different attitudes in old China and Europe toward the purpose and uses of the visual arts. The modern Chinese word for art is "yi shu"; it is not an indigenous term but rather comes from a Japanese translation of the English word "art." Traditionally, Chinese arts and crafts were mainly grouped under the term "bai gong" (meaning "the hundred crafts"). Few of these artistic practices

have the social status and cultural sophistication suggested by the European idea of "art." Especially notable are China's architecture and sculpture, whose social and artistic positions are significantly inferior to their European equivalents. The only arts that may justly be compared are the three media approved by the scholarly literati: calligraphy, painting and seal carving. Beginning with the dramatic rise in status of "literati painting" in the Song dynasty, aesthetic criteria for painting shifted strongly toward a connoisseurship of calligraphic brushwork, bringing a unique bond between the art of calligraphy and painting. As a result, all three recognized fine arts in traditional Chinese culture: calligraphy, painting and seal carving, were effectively affiliated with the written word.

An obvious explanation of this phenomenon, from the perspective of power structure of Chinese society, is the stability of China's agrarian society and its bureaucratic political organization, which over a very long continuous history had been managed by a learned scholar class with a vested interest in the art of the written word. As to the popularity of calligraphy as a fine art we must look at the content of China's educational tradition. The subjects of learning that guaranteed access to a political career were history, classics and literature, which were based primarily on classical, principally Confucian texts that had been widely distributed for centuries and were readily available. Granted that in any educational undertaking, even though one needs the benefit of good teachers to attain true mastery, the curriculum required to take China's examination to become an official was so general that it was accessible on many levels. This system is in striking contrast to modern technocratic government employees with specialized training (such as law, engineering or even sociology), which tends to favour a privileged group possessing specialized knowledge. The world of knowledge within which a Chinese scholar-official operated was the same with which an educated commoner could identify. In fact, within that world the specialist (or the technocrat) was not regarded as a man of learning; he was respected only as an elevated form of craftsman. Thus, the knowledge necessary to attain power was not reserved for a privileged class, but was open, theoretically, to the entire population. If there was a prejudice in the

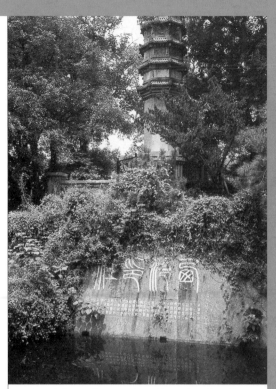

Garden of Xiling Society, Hangzhou, with text incised on side of pond wall,early 20th century

system, it was designed to handicap the merchant class, who were forbidden to sit for examination. Therefore, over the centuries, pursuing the parallel careers of scholarship and farming became an ideal for families with economic means. Since the "knowledge of power" was a traditional group of classical studies familiar to the population, a fine art dependent on the tools of learning (namely calligraphic writing) also became an aspiration for every student. Therefore, calligraphy may be said to be truly "democratic" in spirit. Everyone who could read and write had an opinion on it. Everyone had the right to speak as a practitioner of the art.

SPIRITUAL CULTIVATION AND EVERYDAY LIFE

In recent decades, many attempts to reinvent calligraphy as a "modern" art have emerged, but most of these have failed because of the tendency to either stylize the written form or to exaggerate the calligraphic hand in order to create a new pictorial language. Often inspired by Western experiments in abstract painting, these are innovations based essentially on graphic considerations. One of the reasons for their negligible impact on calligraphy as a whole has

to do with how calligraphy is customarily read and enjoyed. Calligraphy is intended to be read as a text, and is not primarily aimed at visual impact alone. The reader's eyes start at the top right, moving downwards line by line, from right to left. Within a single word, there is also an ordained writing order, from top left to bottom right. Through this reading pattern, the internal rhythm and structure of calligraphy are manifested. In painting, there is no fixed rule to the pictorial structure, and several readings are often equally valid. More importantly, calligraphy by nature differs from painting in its functionality. It is both art and tool, inseparable from the content it conveys. Indeed, calligraphy would be a different kind of art without its practical application. This deference to pragmatism is characteristic of the Chinese view of life.

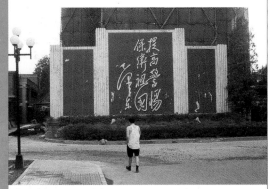

Billboard with Mao Zedong's text and calligraphy

In Europe, the specialization of knowledge that came with the Enlightenment in the eighteenth century gave the arts a new identity and an independent moral responsibility. This transformation of status did not happen to the Chinese crafts until recently. Instead, the modern art academies of the 1920s attempted to regulate the Chinese fine arts of calligraphy and painting to conform to European models. A "scientific" method was imposed on Chinese painting, injecting it with Western theories of perspective and representation. However, this examination of space could not work on calligraphy.

The crux of the matter here does not lie in artistic concerns but is embedded in very different cultural approaches to spiritual life and moral cultivation. In eighteenth century Europe, the moral value of artistic "beauty" and "truth" was treated as an absolute, a tendency that reached a zenith during the Romantic era, when the inspired

individual was deemed to be blessed with divine insight. The adulation of the artistically inspired has continued to be a strong force in Western society, reflected in the popularity of museum visits on Sundays for those who have abandoned religious services.

In China, the tradition of Confucian ethics has directed spiritual life toward the individual's moral cultivation, and fine art was perceived as a discipline toward such an end. The official endorsement of the interpretation of Confucian classics by the great Neo-Confucian philosophers of the Song dynasty further emphasized the importance of reining in one's heart and seeking truth through an alert attentiveness to the mundane routine of daily life. The idea of a redeeming god or any outside agent of rescue was alien to the traditional intellectual. Since China did not have a clergy that regulated spiritual life, whoever aspired to the "Tao" (the "Way") had to turn inward and seek enlightenment within his everyday professional life.

Both Confucian scholars and Taoists emphasized the importance of cultivation and discipline for perfecting earthly life. Spiritual cultivation was open to everyone, in any profession. Whether one's career was in fine art, martial training or classical scholarship, each could be the way to the "Tao," which explains the famous example given by the philosopher Zhuangzi (third century B.C. or before) of a butcher whose perfect skill in slaughtering an ox illustrated the manifestation of the Tao. The emphasis on spiritual truth revealed in everyday life made every career worthy of pursuit. The art of calligraphy follows naturally as the literary man's spiritual exercise. If it had been divorced

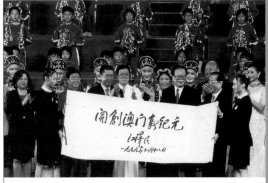

President Jiang Zemin presenting the Chief Executive of Macao with his calligraphy to celebrate the return of Macao's sovereignty to China on December 20th, 1999

from its pragmatic roots and transformed into a "pure" art, calligraphy would have lost its significance. Calligraphy worthy of the Tao was therefore not often consciously created as an artwork, but came about by chance through execution. Among the most esteemed pieces of calligraphy throughout history, not a few were created under force of circumstance in the form of letters and essay sketches, among them are **Preface to the Orchid Pavilion Gathering** (353) by Wang Xizhi (c. 307–365) and **Draft of Essay for Funeral Service of A Nephew** (758) by Yan Zhengqing (709–785).

PARADIGM AND INTELLECTUAL ORDER

Since calligraphy was both a popular art in traditional China and also one that represented political and cultural powers, aesthetic judgement for calligraphy was used to reflect political alignment. The indisputable position occupied by Wang Xizhi in calligraphy's history was secured by the imperial patronage of Tang emperor Taizhong (ruled 627–649), who both copied and eulogized Wang's art. When Song emperor Gaozhong (ruled 1127–1162) declared his admiration for Wang Xizhi, it was not just a pronouncement on art but also a declaration of the legitimacy of his rule and his worthiness as a successor to the great emperor Taizhong. The lineage traced in calligraphic history reflected cultural and political value, hence the collecting and study of calligraphy (including stelae reliefs and the rubbings made from them) were important political tasks. When Empress Wu Zetian (ruled 684–704) embarked on her celebrated political reforms, she also undertook

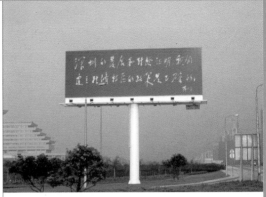
Highway billboard with calligraphy and text by Deng Xiaoping, 1999

an equally praised cataloguing of Wang Xizhi and his family's surviving works. The great official calligraphic anthologies endorsed by the Song emperors Taizhong (ruled 976–997) and Huizhong (ruled 1101–1125) represented significant statements on the levels of achievement of calligraphers as well as the official position on cultural history. It was to be many centuries later, during the era of Qing emperor Qianlong (ruled 1736–1795), before another major anthology was undertaken to demonstrate the legitimacy and power of the minority Manchu government. Likewise, in 1889, reformer Kang Yuwei (1858–1927) published an influential treatise on calligraphy, extolling the superiority of early calligraphic texts carved on stone over the works of Wang Xizhi and later calligraphers. This treatise had an important bearing on calligraphic style; but more importantly, it articulated the views of the Gongyang School of Confucian historical studies, which sought to legitimize political reform through the revival of archaic models.

From the perspective of ordinary people, models of superb calligraphy were provided by readily available reprints of famous works from the Tang and Song dynasties. Beginning in the nineteenth century with the rise in popularity of styles from stelae preceding Wang Xizhi (before fourth century), one's choice of calligraphic models also reflected one's cultural and political leaning. From this relatively recent debate on calligraphic style, one can see how heavily archaism weighs as authority on the Chinese view of lineage and legitimacy. The attraction to incised stelae styles was very much dependent on the fact that they were predecessors of the "standard script" of the Tang dynasty, reflecting also the growth of scholarship based on pre-Tang, classical materials.

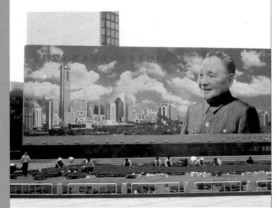
Billboard with portrait of Deng Xiaoping, photographed in 1999

Generally speaking, no matter which style dominated at a particular time, paradigms of calligraphy were always picked from the past, from the golden eras of each style.

Models played an important role in the machinery of Chinese culture, establishing the pantheon of the classics and signifying the authority of lineage. The authority of paradigms gave order to history, and the role of the literati had always been to safeguard the classics and to lay the groundwork for new paradigms in interpreting current events. Since paradigms were time-tested, the traditional Chinese view of history had always been retrospective. One must honor experience, and neither abandon wisdom for the glamor of the moment nor fall prey to empty, eschatological promises of the unpredictable future.

Shop signs bearing calligraphy by Mao Zedong, Guo Muoruo (celebrated poet favoured by Mao) and Qi Gong (member of the last Manchu imperial family), photographed in 1999

Today, the "modernity" of Chinese culture is reflected in the dominion of the icon over calligraphy, and in the re-structuring of calligraphic paradigms. Although calligraphy has rapidly declined in popularity since the mid-twentieth century—when the use of the Chinese brush in daily life was gradually replaced by other writing instruments—calligraphy still played an important social function from the start of Mao Zedong's Cultural Revolution in 1966 until Deng Xiaoping's ban of the Democracy Wall in Beijing in 1979. During this period, one of the most important channels for expressing political views was through the writing of public posters, and people from across the nation participated in current affairs through what was known as "big-character posters" and "small-character posters." These posters were mainly brush-written texts, mostly anonymous and engaged with political issues of the day. Meant to communicate with urgency, they

were calligraphic tracts written in the spirit of the time. This was probably the only period in the modern era when calligraphy truly captured the Chinese visual landscape and held the attention of the masses. However, that also was an era when the visual landscape was shared equally between the written word and the icon, with Mao's portrait and images of revolutionary heroes comprising the only officially approved pictorial iconography. One may justly claim that the years of the Cultural Revolution represented the point in history when the power of the word started to be surpassed by the political icon. Yet even so, the supreme example of calligraphy at that time was Mao Zedong's personal calligraphic style.

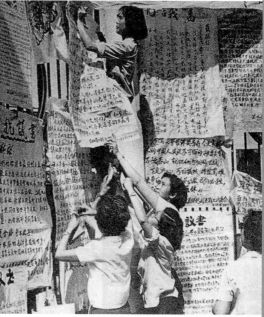

Posting big-character posters, 1967

In Chinese history, there are numerous examples of emperors who were outstanding calligraphers; however, imperial calligraphy was rarely emulated. The modern exception to this is Mao Zedong, certainly the most copied calligrapher of the twentieth century. During Mao's rule, his calligraphy dominated the Chinese intellectual and civic landscape, influencing to an unprecedented degree the people's judgment of the art of calligraphy. (One should remember that in Mao's era nostalgia for Chinese traditional culture was outlawed, and historical models of calligraphy were thus severely limited.) Until now, most major newspapers still bear his handwriting as their logos, which are sent nationwide daily.

Dollar bill of National Republic of China, 1935

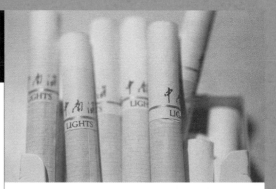

Zhongnanhai Cigarette, logo in Mao Zedong's calligraphy, 1999

We might read this phenomenon as a "modernization" of paradigms, which are no longer drawn exclusively from classical examples tested by history. From a broader perspective, this reflects a shift in China's outlook on time and history. It implies that modern China is no longer a continuum; old paradigms no longer serve contemporary purposes. The ideology of the Cultural Revolution condemned everything preceding it as the product of "feudalism" (or semi-colonial feudalism), stigmatizing the past with the taints of injustice, backwardness and detestable values. In other words, the only true Chinese history worthy of preserving started yesterday, beginning with the arrival of Communism. Today, the tendency is to project a linear outlook onto the future with the support and fervor of ideological constructs, whether these are Communist or capitalist.

WORDS, THOUGHT AND INFORMATION PROCESSING

Unlike words composed of alphabets, character words can indicate meaning through their pictorial form. Although most character words are compounds of "radicals" (units of basic characters or parts thereof), one of the radicals usually serves as a semantic marker. This suggests that the character writing system has a closer, or at least different, affinity with the "real" world. It is interesting to speculate whether such a language system shapes methods of thinking, perhaps even providing unique ways of perceiving the world. Instead of capitalizing on the strengths of the Chinese language, twentieth century reformers and politicians made many serious attempts to abolish the character word, if only on a gradual basis. A national program of simplifying the writing system, together with a gradual Latinization, which later failed, was undertaken from the 1950s until the 1970s. This unfortunate situation should be read in the context of Chinese modern history as a whole.

The radical transformation of Chinese culture in the twentieth century, or more accurately the moves to undermine it, was to a large extent caused by a loss of confidence in its value and relevance. One of the reformer's main arguments criticized the supposed backwardness of the Chinese language: castigating it for lacking a phonetic alphabet system. This misreading of its value largely came about through the erroneous idea that the West's superiority in modern science was linked to its language systems. To be fair, modern life has put serious pressure on the Chinese language system, especially in the field of information processing, which became more apparent with the advent of computers.

Information processing has made the case for changing the Chinese language to a phonetic system: how else could one arrange thousands of characters in a manageable order? The issue is whether the mind itself has a simple way of ordering all these character words. Or, we may ask this in reverse: is there a clever internal logic to characters that allows them to be remembered easily? On a practical but hugely significant level this problem involves a viable method for capturing Chinese vocabulary on a keyboard. The threat to the survival of character words was finally lifted in the 1980s with the invention of a keyboard system that respected the Chinese habit of thought and of character writing.

The first major success was Wang Yongming's "Five Stroke Character Code" system, which has continued to remain one of the most popular input systems in China in spite of later competitors. Putting it simply, Wang devised a way of using the keyboard so that keys are like brush-strokes of characters. The two main challenges he resolved were, first, that the habit of handwriting, working from the top left of the word down to the bottom

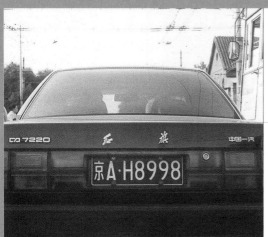

Red Flag sedan car, logo in Mao Zedong's calligraphy, 1999

right, had to be preserved, and second, that the physical form of the word and how it is habitually perceived must not be altered. Not only has the "Five Stroke Character Code" succeeded, its speed is even competitive in comparison with phonetic alphabetic languages, removing a principle handicap for character writing in the information age.

Culturally speaking, efficiency is not the only issue. The more interesting question is, in what ways does character writing affect a Chinese mind's perception of the world, compared with the alphabet system's influence? This is not an artistic question, but it may be illustrated with art. The "naive" painter Hung Tung (1919–1987) grew up in a remote Taiwanese village where there was no cultural establishment apart from a Taoist temple. He was practically illiterate, knowing only a handful of characters. His paintings, however, portray creatures and objects of the world as though they were some form of fabulous character words. He populated his works with his own form of miraculous "character" figures. The closest relative of Hung Tung's art is probably Taoist magic writing (a form of illegible "character" writing used in magic rituals) with which Hung was familiar. The interesting message of this art is its sense of graphic form, suggesting that Chinese perception may inherently be shaped by the world of character words.

With its revolutionary speed and accessibility, information technology threatens all forms of handwriting, and the threat promises to increase with time. However, in threats are also hidden opportunities. It is obvious that brush-written calligraphy is no longer practical in contemporary life; yet, new visual spaces for the public today are not restricted to buildings and city streets; they include information space or cyberspace. From this new world of information arise new possibilities for pictographic cultures, whether Chinese characters will offer new tools and fresh impetus within this open horizon remains to be seen.

CONCLUSION

In terms of Chinese contemporary art, it is obvious that the culture of character words continues to offer a rich field for exploration. Calligraphy is a major link to a unique historical culture that is in the process of reinventing itself for a new age, and the art of the word presents the prospect for artists both to step forward and look back at the same time. The incarnate presence of the written word made its impact on Western avant-garde art at the beginning of the twentieth century, and since then, the effects of commercial advertisement and mass political movements have completely transformed the significance of writing. At the end of the century, the ubiquity of electronic mail and cyberspace have again established new links between everyday life and the written word, and creative possibilities in this area are prolific. With the benefit of its art history, how Chinese artists creatively investigate the implications of the written word will not only add to China's heritage, but also certainly to the legacy of art of the world.

Chang Tsong-zung is a curator, art critic, and scholar living in Hong Kong. His exhibitions on contemporary Chinese and Taiwanese art have been presented at many institutions, including the Kunstmuseum Bonn, the Museum of Contemporary Art in Sydney, the Shanghai Museum of Modern Art, the National Gallery Beijing, the São Paulo Bienal, and the Venice Biennale.

Photographs illustrating this essay courtesy of Chang Tsong-zung, Qiu Zhijie and Yan Shancun.

ARTISTS AND WORKS
Texts by Chang Tsong-zung

Born 1951 in Guangdong, China. Resides in New York and Taipei.

Rules of Reading

The cultural significance of the tradition of calligraphy in China is immense. Every literate Chinese person practices calligraphy. It was and still is considered the highest of the fine arts. As an example of personal cultivation on a mass level, calligraphy is an amazing phenomenon in human history. Calligraphy as art implies that personal sophistication should be pursued within the discipline of one's professional life. In other words, it implies that personal, spiritual gratification can be found within one's professional mode of production. Labor need not be an alienating process. This attitude towards work and personal well-being was traditionally embedded in all walks of Chinese life. Modernity has perhaps brought an end to this. The computer revolution has also made the profession of brush writing outmoded. This means the connoisseurship of calligraphy must seek fresh approaches.

Historically, the appreciation of calligraphy has been based on an understanding of classical models, and quality was determined through comparison of contemporary and old masters. The approach is diachronic. Another approach is structural and analytical: it attempts to change the rules of connoisseurship without being subjected to the test of traditional craftsmanship and attempts to reinterpret the art without following historical models. Fung Ming-chip's work is an example of the latter.

As a seal engraver, Fung Ming-chip is interested in the possibility of recovering the pictorial root of words in order to turn words into a version of figurative art. As a calligrapher, he emphasizes the relationship between reading and calligraphy. The narrative process of reading instills into calligraphy a special structural sequence and spatial configuration. It is a form of picture-making fixed with special rules. Fung Ming-chip moves to distort or exaggerate these rules in order to make writing and reading transparent, in the process creating a distinct style of his own. He playfully invents new types of "scripts" to study the dimension of time in spatial structure, often using his own poetry as the text. In an age when the mass base for this art has disappeared, Fung Ming-chip's experimental calligraphy serves to recover the possibility of calligraphy as an art for personal cultivation. He offers us eclectic and individual experiments suggesting that perhaps they are the solution for the new generation.

opposite:
Command of Wind and Rain, 1992
Bronze
34 3/8 x 31 1/4 x 5 1/4 inches

following pages (left to right):
Buddhist Heart Sutra
(written in *Light Script and Transparent Script Couplet),* 1997
Ink on rice paper mounted on scroll
Two scrolls: 27 5/8 x 27 5/8 inches each

Four Seasons, 1985
Acrylic on wood relief
Four panels: 48 x 12 x 1 1/4 inches each

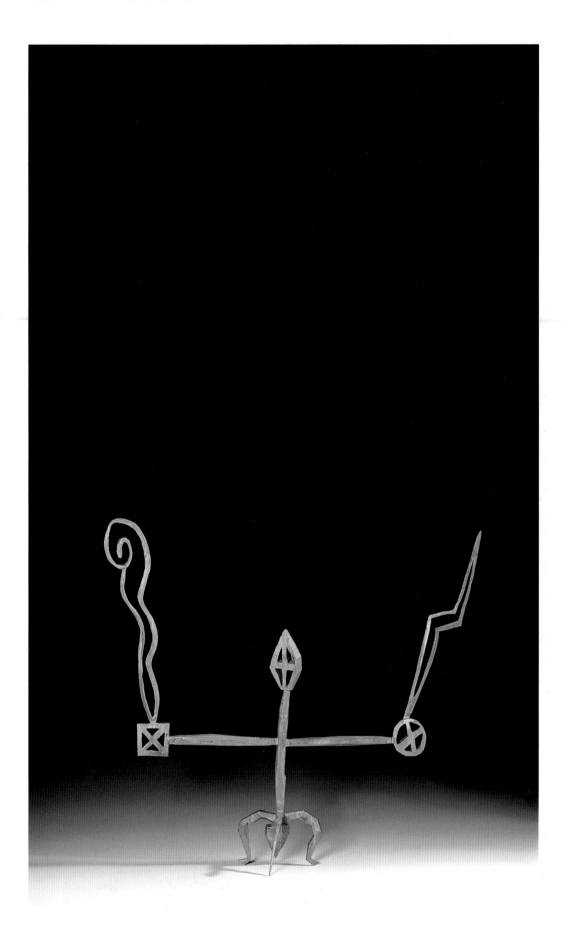

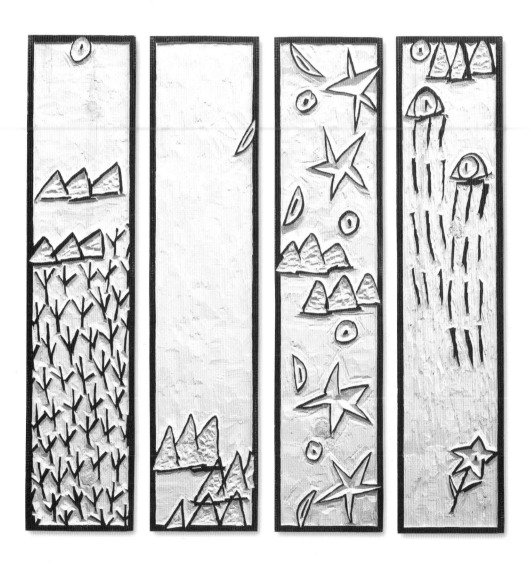

Born 1955 in Shanghai, China. Resides in New York and Shanghai.

Totem and Taboo

Gu Wenda was among the first radical artists in post-Mao China to exploit the power of calligraphy for avant-garde art. From an intellectual and contemplative art, Gu Wenda has changed calligraphy into an explosive and threatening contemporary means of expression. He has explored the power of calligraphy as a public language, inspired by the example of Cultural Revolution "big character posters" (political statements written and widely disseminated but tacitly sanctioned by the ruling faction of the day).

His art has highlighted the provocative authority of public announcements and prohibitions. In the *Sky Dynasty* series, large character words loom out of clouds suggesting supernatural apparitions. Transcending the role of the mere sign, the presence of words amidst landscapes allows them to take their place among the natural elements as another, or perhaps more potent, substance.

Reviewing Gu Wenda's works from his word paintings to installations incorporating bodily substances such as menstrual blood, placental fluid, and hair, it becomes apparent that his creative power is derived from the breaking of taboos. In 1984, Gu Wenda started to experiment with error words, challenging the sacred ground of correct word forms that represent stability and order. His later use of body parts likewise evoked deep-rooted taboos as they suggest an interference with the human life cycle. The power generated from collecting hair from anonymous donors is comparable to the threat of the sheer volume of humanity: each strand of hair carries a person's full DNA code. The hair, shaped into words (or pseudo-words), gives an identity and a humanity to these otherwise anonymous masses. In Gu Wenda's art, culture and nature merge to present something larger than either one alone, and restores to the word its primal cultural power of giving meaning to life.

opposite:
The Modern Meaning of Totem and Taboo, 1986
Ink and watercolor on paper
One of three: 113 5/8 x 71 1/4 inches each

following pages:
Mythos of Lost Dynasties, 1999
from the Sky Dynasty series
Two of nine scrolls 132 x 60 inches each

The Praying Wall, 1993–1997
From the United Nations 2000 series
Human hair and white glue
Twenty panels 78 x 48 inches each
(installation dimensions variable)
(Four panels: Sanskrit; four panels: Chinese;
four panels: English; four panels: Arabic;
four panels: mixed scripts)

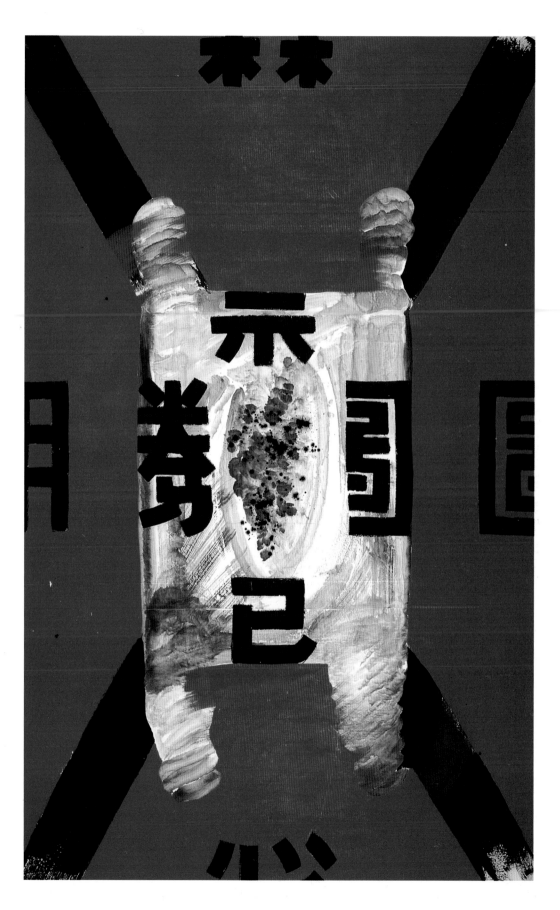

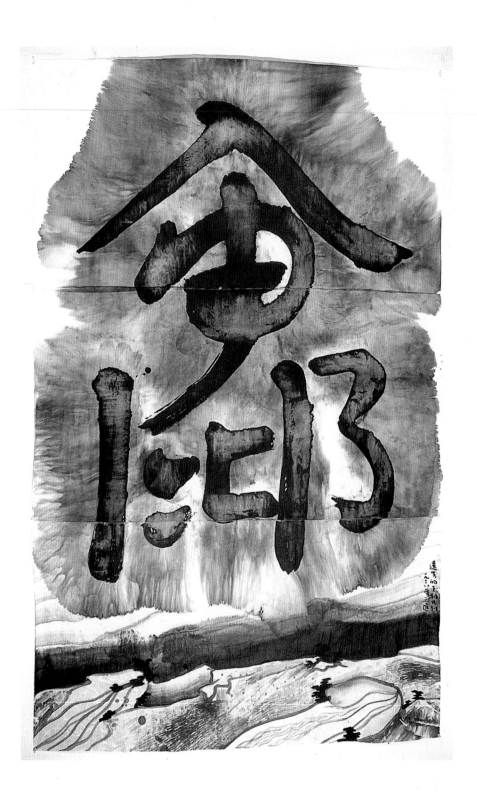

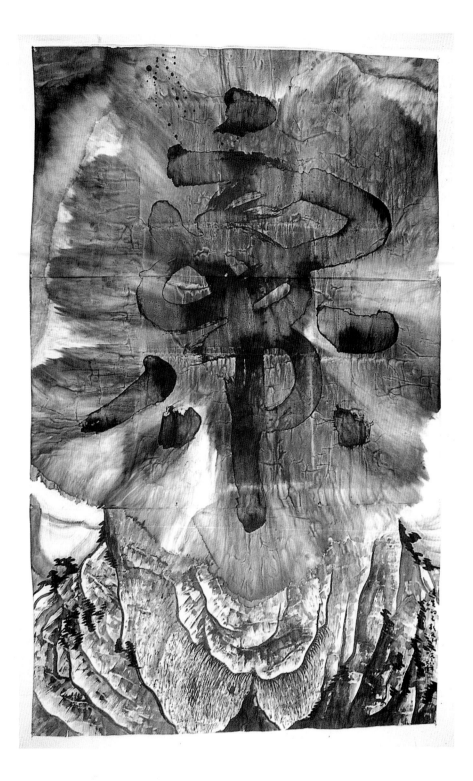

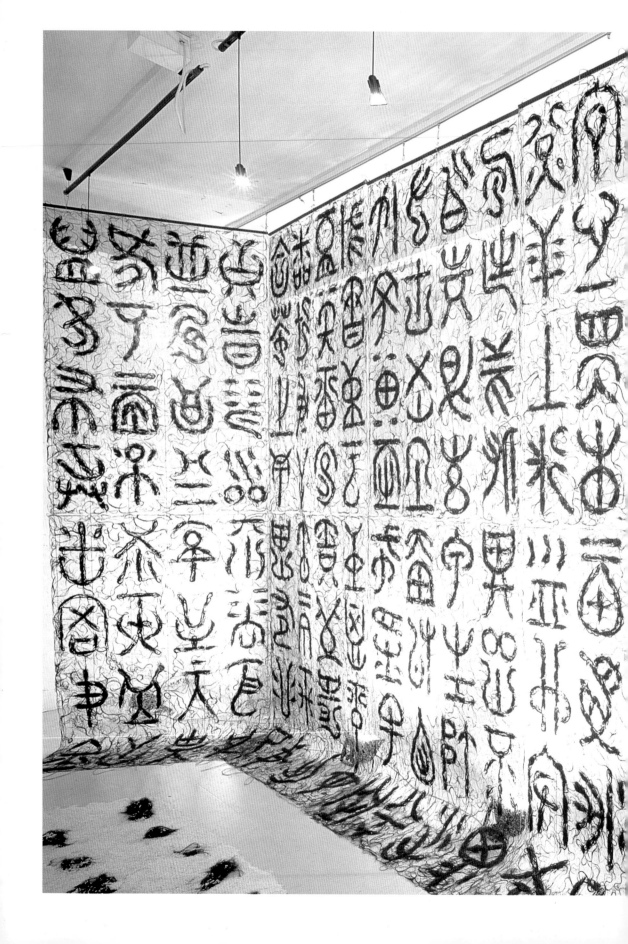

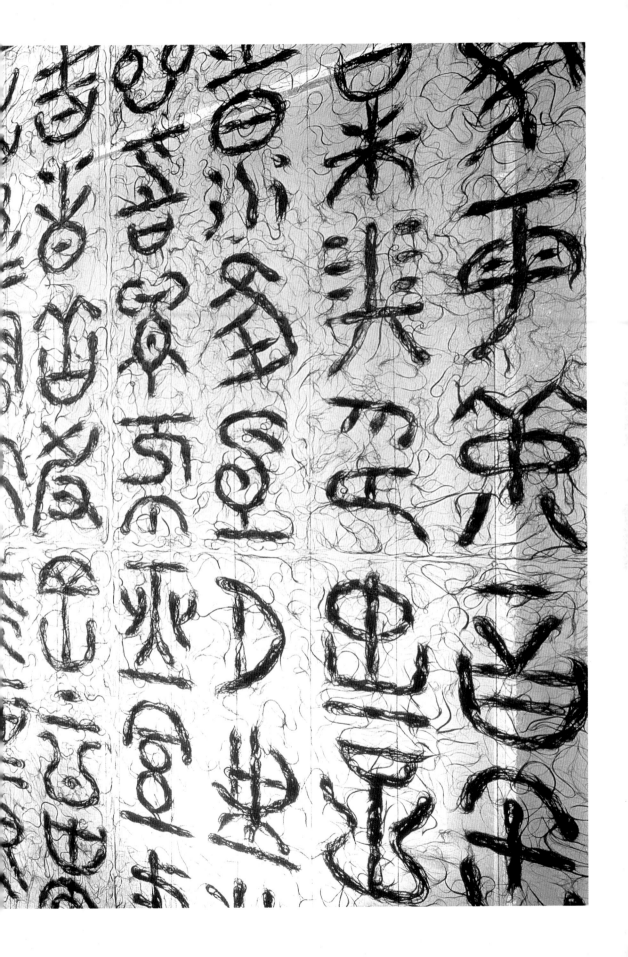

Born 1920 in Tainan, Taiwan. Died 1987.

Code of Life

When Hung Tung appeared on the art scene in the 1970s, he was immediately taken up as a hero of the emerging Native Soil movement. In actuality, Hung Tung was an outsider to the art scene. Practically illiterate, he started to paint seriously at the age of fifty, after a life of farming. Hung Tung's magical world is a realm beyond the modern urban experience, and yet he seems to have built his pictorial world upon a mysterious, coherent system that may be of interest to contemporary thought. Hung Tung's paintings are full of small irregular patterns which, like jigsaw pieces, build with each other to create recognizable forms. At the base of these patterns are small cell-like components, some bearing eyes, that demand an interpretation as small units of life. The growth of these cells into the creatures of Hung Tung's world is guided by mysterious patterns that prevent the creatures from becoming purposeless, cancerous organisms.

Seen from a wider perspective, Hung Tung's secret patterns seem to suggest that the structure of his world is based on mysterious Taoist cosmology, familiar to the artist from his local temple. On a smaller scale, the building of biological bodies seems to be guided by secret codes. In truth, Hung Tung's secret pattern codes are a personal version of character words.

As an illiterate, Hung Tung's secret words are impenetrable to all. But as a Chinese person with Taoist knowledge, Hung Tung's idea of codes is clearly borrowed from Taoist magic writing. The bodies of *Butterfly God* and *Helu!!* are examples of such magic character words. Comparing the two types of figures riding the *Phoenix Boat*, one with color cells and one drawn solely in black lines, it is impressive to see how, in Hung Tung's world, the sense of form has been influenced by the shape of word. A survey of Hung Tung's oeuvre reveals similar working methods: physical bodies consistently develop into word-like form. This may make us wonder whether a mind cultivated in a character word language perceives the physical world in a particular way. In identifying figures with words, Hung Tung's art also raises important issue about the special position held by words in the study of languages.

opposite:
Butterfly God, approximately 1976
Ink and gouache on paper
70 3/4 x 33 1/8 inches

following pages:
Untitled (HT-53), approximately 1975
Gouache on fiber board
16 3/8 x 24 1/2 inches (unframed)

Couplet, 1977
Ink and gouache on paper
mounted on scroll
(left) 68 3/8 x 17 3/8 inches
(right) 69 1/4 x 17 5/8 inches

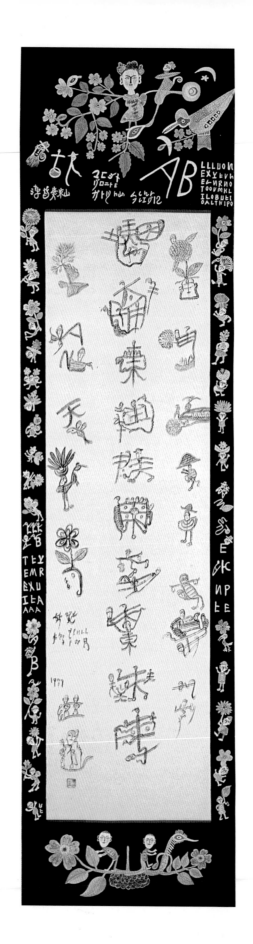

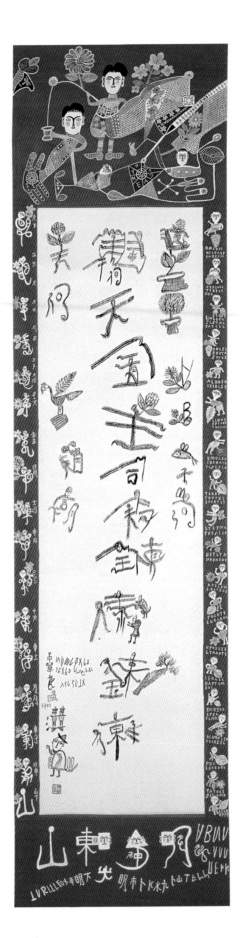

Born 1920 in Guangdong, China. Resides in Hong Kong.

Erased Territorial Claims

Tsang Tsou-choi moved to Hong Kong from Guangdong at sixteen and has lived there ever since. He started to do graffiti calligraphy after marrying at the age of thirty-five, calling himself the King of Kowloon.

For forty years, Tsang Tsou-choi has persisted in this activity, unaware of the world of art. He doesn't even think of his work as calligraphy. His writings cover public spaces: in the street, on utility boxes, on walls and lampposts. He has been in and out of most police stations in Hong Kong for "defacing public property." Tsang Tsou-choi's mission is endless as he needs to recover territory where his graffiti has been white-washed over.

Like most public writings, such as the "big character posters" of the Cultural Revolution, Tsang Tsou-choi's graffiti are a kind of political expression, except that his claims are divorced from the realities of society, and therefore crossing into the realm of fantasy, or art. He explained that he discovered, from going over old ancestry records in the Tsang Clan temple in Guangdong, that the government had illegally taken possession of large tracts of land belonging to his clan. His writings are a public protest of this violation of land rights. Tsang Tsou-choi's texts mostly concern family genealogy, which is almost always fictitious, listing territories his clan members were entitled to. All this is of course an elaborate fantasy, but over time it has also developed its own narrative. What is important is that through his graffiti-calligraphy, Tsang Tsou-choi has conquered the territory of Hong Kong, satisfying an essential link with the land his ancestors claim title to.

As an instrument of territorial claim, public writing has a long history. In format, Tsang Tsou-choi's writings on electric and utility boxes is reminiscent of stone stelae of dynastic days. His writings on mountainsides echo rock engravings commissioned by generals of old to mark conquered territories. Such uses of public writing have deep roots in Chinese cultural memory, and it is ironic to find them manifested in such a natural manner by one who is probably unaware of the illustrious ancestry of his art.

opposite:
All works *Untitled*, 1996–1998
Photographs that document the utility boxes in-situ.
Photographer: Eric Otto Wear

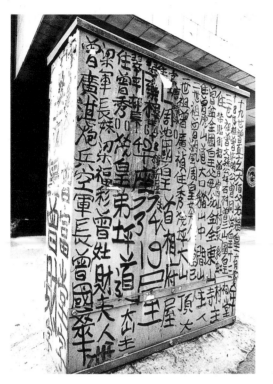

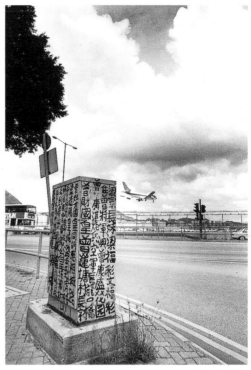

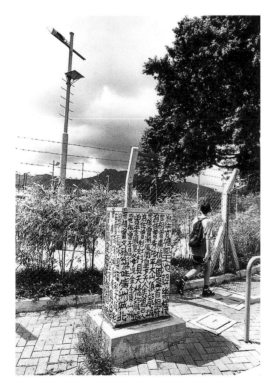

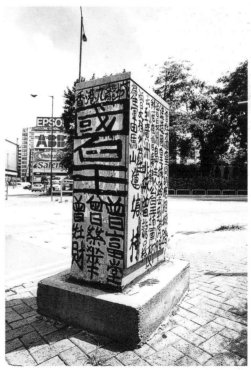

Born 1893 in Hunan, China. Died 1976.

Paradigm of Calligraphy and Calligraphy of Power

From the founding of the People's Republic of China in 1949, Mao Zedong's calligraphy has been adopted as a model of the art of brush writing. The supremacy of Chairman Mao's calligraphy reached its zenith in the years of the Cultural Revolution (1966–1976), when his calligraphy came to represent the most honored, as well as most politically-correct, writing style. Into the 1990s, marking Mao Zedong's centenary celebration, his calligraphy anthologies, even dictionaries, continued to appear, affirming the continued status given to Mao Zedong's calligraphy. Reaching far beyond the current of daily politics, Mao Zedong's brushwork has achieved eminence in contemporary Chinese culture.

From the perspective of imperial calligraphy, Mao Zedong is in the tradition of emperors like Kangxi (1662–1722) and Qianlong (1736–1795) who marked their physical presence throughout the empire with numerous inscriptions fronting famous temples and scenic sites. In the tradition of imperial writing, private acquisition by collectors of Mao Zedong's calligraphy has been discouraged; instead, the work is held in official archives. Yet, unlike his imperial predecessors whose work remained limited to the role and context of imperial patronage and no more, Mao Zedong's calligraphic style has been used as a serious study model.

In the history of calligraphy, Mao Zedong is unique. In terms of the sheer number of followers, he is certainly the most influential calligrapher in the latter half of this century, and this is particularly impressive in light of the fact that calligraphy has always been one of the most widely practiced forms of art in China.

Outstanding calligraphy has traditionally served as a signpost marking the lineage of history. In painting, Chinese scholars have always looked to the Sung and Yuan dynasty masters; in calligraphy, the high models were taken from the Tang and pre-Tang dynasty masters. The implication has always been that true authority lies in the past. Mao Zedong, as a paradigm of calligraphy in current political culture, reverses this view of history. The highpoint of cultural authority, it is inferred, now rests in the present. By instituting language reforms, Mao Zedong's regime also effectively changed the rules of the game, implying that new paradigms are not only a reality, but also a necessity.

Mao Zedong is the crucial figure of this political age in China both in terms of his calligaphy and his position in the visual culture of political power. His calligraphy has made him a landmark in the history of China's word culture, while his face as icon has famously come to represent the power of modernity.

Mao Zedong has come to straddle the transitional world of word and image culture, and what we now must ask is whether present or future Chinese political leaders, schooled in the information-age of computers, will still be able to exert political authority through the written word.

opposite:
Ode to the Plum Blossom, (Poem dated 1961, calligraphy undated)
Facsimile reproduction on paper mounted on scroll
20 x 59 1/8 inches (including scroll mount)

卜算子 咏梅

读陆游咏梅词，反其意而用之。

风雨送春归，
飞雪迎春到。
已是悬崖百丈冰，
犹有花枝俏。

俏也不争春，
只把春来报。
待到山花烂漫时，
她在丛中笑。

毛泽东

Born 1969 in Xiamen, China. Resides in Beijing.

From Conformity to Paradigm

Since his graduation work, an installation titled *New Life*, Qiu Zhijie has shown a sustained interest in the problem of conformity. He is intrigued by the homogenizing effect of the environment on the individual, and has tackled this issue in works of different media. The video work *Washroom (Face with Grid)*, 1997, shows a face painted with a grid pattern that merges with the background, only to be disrupted by the creation of an expression. The photography series *White Collar Workers* shows office workers in suits and ties striking poses from Cultural Revolution operas; they look absurd because two disconnected symbolic systems have been deliberately juxtaposed. Qiu Zhijie seems to say that the individual is made to blend into his environment, and personality can only emerge when disturbances, like ripples in a still pond, displace the surface. Conformity is the foundation of language; personal voice is the discipline of movement through conformity to creativity and beyond.

In works relating to writing, *Copying One Thousand Times: The Orchid Pavilion Preface, April 8th* and *The Nine Court Square*, Qiu Zhijie shows that compliance to rules and copying models form the basis of the discipline of calligraphy. The writer's individuality emerges only through willing subjugation to discipline, and through self-effacement. In *Copying One Thousand Times* Qiu copied *The Orchid Pavilion Preface*, originally written by Wang Xizhi in 353 A.D., a thousand times on the same sheet of paper until it became totally black. *The Orchid Pavilion Preface* is the most famous piece of calligraphy in Chinese history, but Qiu Zhijie's consideration when he picked this work was not artistic; like a Pop artist, his choice was determined by the work's fame. Qiu Zhijie demonstrates that the myth of the great paradigm is sustained by an act of faith, and yet, only through this faith and the rigor of discipline, can the student enter the cultural and spiritual world of his model. The way to the spirit is a concrete practical path; the student imitates the physical movement of the master's writing hand, in turn hoping to recreate the spirit that originally inspired it. Like the faithful saying prayers, a calligrapher achieves freedom through giving up his obsession with the self.

The issue of models is not just about language, but also about power. Historical consensus has rendered *The Orchid Pavilion Preface* the absolute paradigm of traditional calligraphy, but the models picked for *April 8th* are completely arbitrary in both their choice of writers and text. Qiu Zhijie invited different people, factory worker included, to copy a prescribed newspaper and then using their calligraphy as models. Qiu Zhijie seems to suggest that although paradigms are unavoidable, choice should still be questioned in order to understand the power structure that determines it. Underlying all of Qiu Zhijie's work is the implication that spiritual life emerges from the activities of physical life; mundane activities may acquire meaning and culture under the effective guidance of the mind.

opposite:
April 8th, 1996
Mixed media installation
(photo of artist in the process of copying the Beijing Daily of April 8th, 1996)

following pages:
Copying One Thousand Times "Preface to Orchid Pavilion," 1995–1996
Ink on paper: 27 x 62 1/2 inches
(work in progress found on inside front and back covers)

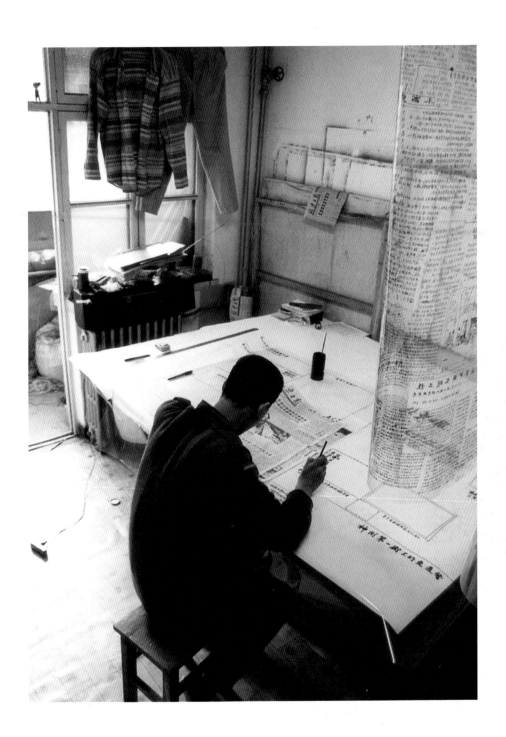

WANG YONGMING

Born 1945 in Henan, China.

Back to Characters

China has never seen so many proposals for reforming its language as in the twentieth century. Apart from the simplification of characters successfully enforced in the People's Republic of China since 1949, there have been more radical proposals for alphabetizing the language. The arguments always involve combatting the difficulty of learning Chinese characters and, by implication, arguing that a phonetic language system is more advanced. As a result, the reformation of Chinese writing has been at the core of modernization efforts in China. This reflects a loss of confidence in Chinese culture as a whole—a situation open to political exploitation.

With the spread of commercial computers since the 1960s, the difficulty of inputting characters into the computer system has made the conflict between character word and phonetic system even more acute. Until the 1980s, the only viable Chinese input systems had to turn character words into phonetic components, which put great pressure on language reform if China intended to keep up in the age of communications technology.

The situation was turned around in the 1980s with the appearance of various input methods sympathetic to Chinese characters, the most important being Wang Yongming's *Five-Stroke Character Code*—a system that manages not to distort the way character words have always been written. This means one can almost think and construct words with the computer as one would by hand. Although this system is adapted only to simplified characters, comparable systems for traditional standard characters have appeared in Taiwan. The success of this system is built upon the efforts of many predecessors; Wang Yongming's teacher, Zheng Wanli is particularly noteworthy, as is the scholar Lin Yu-tang, who devoted decades of effort and his entire life savings to designing the Chinese typewriter.

The genius of *Five-Stroke Character Code* lies in breaking down words into five types of writing strokes and applying it in the order of handwriting, from upper left to lower right. Wang also breaks down structural forms of words into several types. He has numerous historical precedents, the most famous theories include Madame Wei's *Scheme of Strokes* (fifth century), Ou-Yang Xun's *Sixteen Structural Forms* (575–641) and Wang Ji-yuan's *Ninety-Two Structural Forms* (nineteenth century).

Five-Stroke Character Code requires at most four keys per word, averaging only 2.6, and an average skilled typist can enter 120 words per minutes, which can be augmented to over 200 with the use of codes for word phrases. At this rate, typing in Chinese nearly doubles the average rate of typing in English. Research also suggests that the information loading of characters in a computer well exceeds that of alphabetic languages, which makes one wonder if the learning capacity of a person using character words may not be superior, if one assumes the mind works in ways comparable to the computer.

In the nineteenth century, European linguistic studies started a major revolution, with scholarly emphasis changing from the study of written languages to the spoken tongue. This development in the study of spoken languages and phonetic systems had a political implication, which was the possibility of providing foreign cultures with written scripts developed from a Western phonetic alphabetic system, adding cultural hegemony to colonial rule. For China, extricating itself from the mire of debate on language reform and the phonetic alphabet remains a crucial step in entering the post-colonial age.

opposite:
Five-Stroke Character Code, 1987
Two computers on tables
Two sets of instructions
Dimensions variable

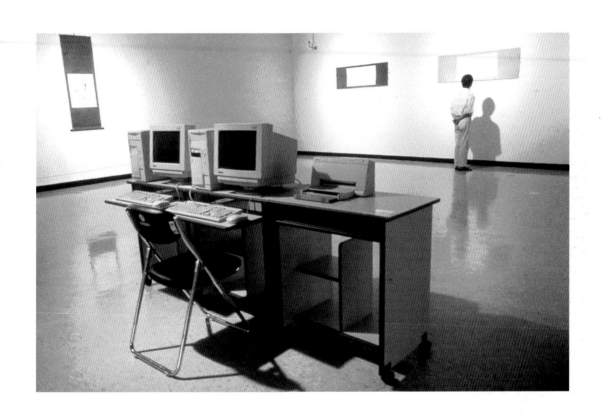

WU SHANZHUAN

Born 1960 in Zhoushan, China. Resides in Hamburg.

Land of Slogans

Inspiration for Wu Shanzhuan's *Red Humour* has clearly come from the visual world of the Cultural Revolution, but the work has a timely significance for the media congested culture of contemporary Asia. Instead of using calligraphy, which implies a personal touch, Wu Shanzhuan uses an impersonal typography to deliver messages of instruction, prohibition, and persuasion. This suggests the dominance of a uniform official facade, an impersonal mask of power. Wu Shanzhuan's work evokes the suffocating space of slogans and announcements but, unlike the years of the Communist revolution, they are messages from diverse discourses, setting up a clash of unrelated worlds.

Wu Shanzhuan's subversive imagination has also entered the structure of ideology, specifically that of language, when he creates confusion in written texts by inventing counterfeit words. Wu Shanzhuan's fake words have another significance in that he presents written words as "figures", stressing the materiality of the written script. Furthermore, unlike artists such as Gu Wenda, who investigate the individual's empowerment through the personal touch of calligraphy, Wu's writing shuns the personal dimension of power. Clearly, his impersonal script is a writing script that comes after the fall of imperial rule. The power implied by Wu Shanzhuan's standardized script is derived from bureaucracy, socialist or capitalist, formed by the unnamed masses.

No Water This Afternoon is a non-narrative story that articulates an internal world reflecting the postmodern public sphere parodied by *Red Humour*. Narration is disrupted by conflicting languages (both verbal and visual), and the multifaceted, internal dialogue is made impossible by the constant intrusion of public language. In front of this work, it is sobering to remember the description of China by early Western travelers as a nation full of poetry, no doubt inspired by the countless poetic writings on public buildings. Today, after modernization, travelers would probably find a land of slogans a more fitting description of the Chinese world.

opposite:
Installation view of Wu Shanzhuan's work as seen at the Taiwan Museum of Art
photo: Roy Lee

following pages:
Hu Shuo Ba Dao, 1987
Ink and red gouache on paper
Four panels: 54 x 53 5/8 inches each
108 x 108 inches overall

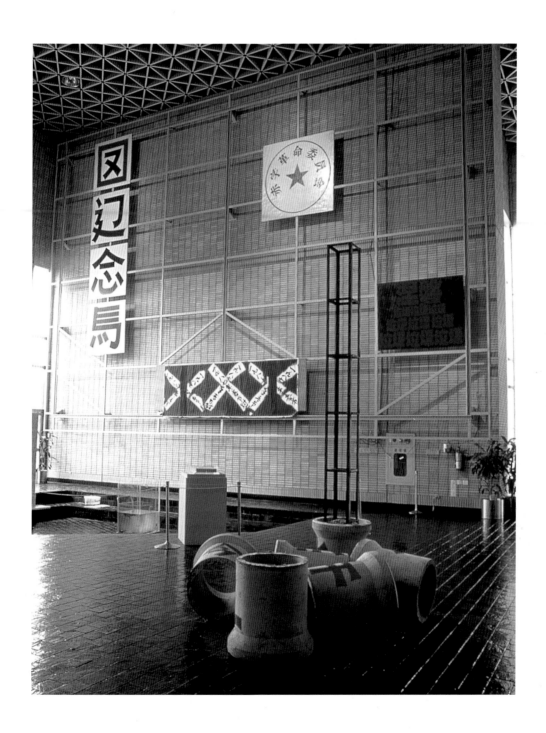

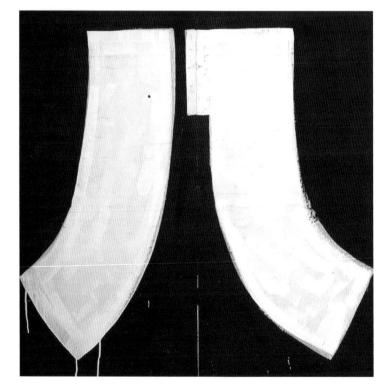

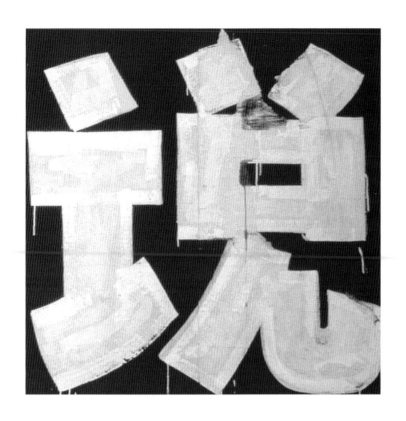
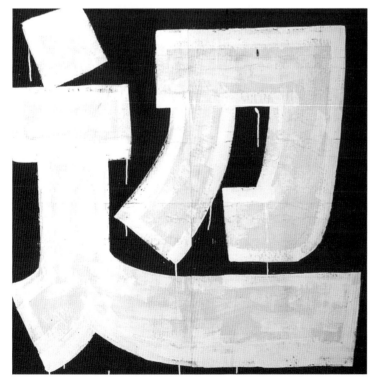

Born 1955 in Chongqing, China. Resides in New York and Beijing.

The Weight of Words

Since departing from his early training as a woodblock print artist, Xu Bing's career has been closely tied to the written character. *Book From the Sky* and *Ghost Pounding the Wall* are monumental works that have pushed the technical and cultural implications of two major traditional crafts of printing to logical absurdity. Wood printing-type may be interpreted as a minimal woodblock print; and for the *Book From the Sky* these minimal prints were produced en masse to create the effect of an overwhelming cultural edifice, challenging the viewer to read and decipher. Yet on close inspection, the book is unreadable, every word is fake, thus lifting the weight of accumulated culture, leaving only amazement at Xu Bing's artistic vision. *Ghost Pounding the Wall* refers to the tradition of relief-rubbing. The act of making a rubbing of a cultural relic imbued with historical memory turns the work into a relic itself. As a monument to the past, the work also reminds the audience of threats to the continuity of Chinese culture in modern times.

Xu Bing's subsequent works also reflect a sustained interest in language, especially in cultural dilemmas arising from communication between a logographic writing system (Chinese character words) and a phonetic alphabet system, such as the English language. Ironic but provocative, Xu Bing's *Clay Words* and *Square Word Calligraphy* promote the genius of character words by adapting the Roman alphabet to a pseudo-character writing system. By transcribing the alphabet into Chinese characters of comparable pronunciation in the *Clay Words*, Xu Bing highlights the hidden absurdity of a character alphabet. He also brings to our attention the opaque nature of written script and its subtle nuances.

Square Word Calligraphy looks like another unreadable word game on the surface, when it is in fact English words compressed into a square format, and designed for practitioners of brush calligraphy. *Square Word Calligraphy* brings out two issues central to calligraphy: one is the historical mission of education, the other is the role calligraphy plays in self-cultivation. Calligraphy has always been the most popular mass art in China, and thus, by extending the possibility of its use by a growing population, Xu Bing has moved to make this art form gain a greater universal hold. The global traffic of languages in this generation has largely been in one direction, with China today claiming more English language students than the entire United States population. Under such historical circumstances, perhaps *Square Word Calligraphy* is a timely invention that helps redress the balance. Or perhaps the art is a kind of black humor, questioning the absurdity of obsessions with word use, brushstroke technique, and cultural continuity.

opposite:
Installation view of *Book From the Sky*
Photo: Roy Lee

following pages (left to right):
Square Word Calligraphy, 1996
Mixed media installation

One sheet of artist's research for *Square Word Calligraphy*, 1994

RiCO

RiCO

P57

LOGOGRAPHIC ART
by Richard Lord

Western admirers of Chinese art have not always found it easy to accept that, from the earliest times, calligraphy has been regarded as an art form superior to that of painting. Why is this so?

One obvious reason is that without an extensive grounding in Classical Chinese, and in calligraphic styles, Westerners are at a considerable disadvantage. They may admire the individual flair of the brushstrokes, and can perhaps learn to distinguish the many different artistic styles. They may even begin, though in a limited sort of way, to appreciate the artistry from a purely iconic point of view. But, ultimately, the scripts lack that most essential property—meaning.

A less obvious reason is that the West has inherited, originally from Greece but later buttressed by the power of Rome, the unfortunate habit of compartmentalizing everything, including artistic domain. From the European Renaissance onward, the various modes of art began to be treated as separate categories. This separation was sharpened by the new scientific orientation toward the graphic arts and architecture, the mathematical transformation of music in Renaissance polyphony, and above all, Gutenberg's movable type and the consequent mechanized process of printing. Art, which was once a single integral part of human life and culture, lost its unified identity and broke into many smaller pieces—i.e., the various arts. Of course, there have been belated attempts to put Humpty-Dumpty back together again: Baroque opera, Goethe's investigations of science, art and literature, the "music theater" of Richard Wagner's operas, or the Symbolist attempts to fuse color, space, sound, and word. In England, especially, there was even a resurgence of interest in calligraphy in the late nineteenth century. But none of these revivals has prodded the art-consuming public in the direction of a renewed holistic perspective.

In China, however, the domain of art has remained, until comparatively recent times, one with the rest of human creative and intellectual endeavor. A realistic Sung ink painting is totally different from an equally realistic oil painting of a tree by Constable. It is some time since I was in the Palace Museum in Taipei, but I can still see vividly in my mind's eye a particular Sung landscape that is a favorite of mine (only rarely on display). The tree does not just represent, it beckons. By this, I mean that the gap that intrudes between the art object and the viewer disappears: represented reality and actual reality merge. Similarly, an overgrown pathway, on a different painting, with all its delight in the unkeptness of untrammeled nature seems to murmur, "Yes, this is the way." What I am trying to say is that the Sung tree, or the overgrown pathway, does not merely appeal to the aesthetic sensibilities of the observer, as it would in the West (before Cézanne or van Gogh) but it speaks to me, communes with me, addresses me as a symbol from the depths of the unconscious.

Even in the urban morass of present-day Hong Kong, experience has taught me that university students are quite unwilling to study, say, philosophy or language without reference to literature, or literature without reference to the rest of human culture. And it was not uncommon for the well-grounded Chinese person to cultivate the various arts along with a special interest, whether it be in commerce or academe. For example, a friend of mine is a specialist in philosophy, but he is also an expert seal-carver and, like almost everyone else of his type, a writer of poetry and a

translator. The age-old "literati," a group of cultivated individuals who engage in a range of artistic activities, are not quite extinct. Indeed, the goal of achieving wholeness (rather than Western all-roundedness) and wisdom remains very much a living ideal among what has probably never been a large minority of people in China.

There is also a third reason for the fragmentation of art, which China has not had to endure. This has to do with the Western concept of language.

In the short space available here, I cannot provide the full treatment that this problem deserves. So an outline—a selective one at that—will have to suffice. First, a few words about the nature of language. As soon as we start thinking about it, we realize the extent to which language forms an integral and indispensable part of our lives. Language, as we know it, is generally considered to be the one characteristic that sets us apart from other creatures. Steven Pinker writes of the "language instinct" and thinks of language as being "so tightly woven into human experience that it is scarcely possible to imagine life without it" [The Language Instinct. Harmondsworth, Middx, England: Penguin Books, 1994, p.17]. Mostly we don't even remember learning to talk. By the time we become conscious that we can speak, we have already acquired the essentials of language.

Language, not surprisingly, can be looked at in many different ways, depending on one's experiences and interests. To someone who has spent a lot of time studying one or more a foreign languages, these will seem to consist of strings of speech sounds and corresponding alphabetic or other writing, falling into sequentially arranged patterns of syllables, words, sentences, and so forth, collectively known as grammar. But mastery of the grammar of a language entails other factors, too.

Complete mastery of a language also means knowing how and when to use (or not to use) the various patterns. In the case of their own language, native speakers normally have no difficulty in acquiring whatever verbal skills they need. Beginning speakers of foreign languages, though, unless they have a special aptitude, have to do a great deal of talking before they feel comfortable in everyday language use.

There are aspects of language that are only poorly understood. The least well understood is meaning. Meaning is obviously central to language, even though it remains controversial.

Many modern philosophers have been skeptical of the concept of meaning and, even in linguistics, meaning was for several decades disregarded, especially in North America. At the opposite extreme, meaning is considered to be the fundamental engine of language in all its aspects. Knowing the grammar of a language and the how and when of language use would be pointless without understanding quite precisely what message or intention is being conveyed.

Meaning is not confined to language but is a realm shared by all the arts, by every social practice, by the whole of a particular culture. Linguistic meaning is different only to the extent that it conveys particular messages, and makes possible effective interaction between or among human beings who share a common language.

There is something mysterious about meaning. It eludes our grasp, and yet it is something we share. In music and art, meaning can be immediately accessible, even though it is usually not too specifiable and interpretation can vary considerably from one individual to another. In language, by contrast, meaning appears much more highly determinate, less subject to individual interpretation provided, of course, one knows well the particular language in which a meaning is being expressed; yet, here too, interpretation is everything. No two interpretations, whether in art, music or language, are ever the same.

A fundamental point to be made is that meaning, on the one hand, and grammar and function, on the other, are distinct, unrelated phenomena. They come together, and become fused—this fusion lasts only for a split second of unrepeatable utterance, or in textual context. in which the words occur. It is the words of that context that commingle meaning and grammar. This coming together is far from rigid, allowing as it does, and depending on the circumstances, for an open-ended degree of "play." Words are only partly language; they are also, and predominantly, pieces of live art—live because they change along with changes in culture and world outlook. Their meanings are instantaneous but their lives are as old as human time: a paradox, so it would seem.

The grammar of a language includes its sounds (as well as its syntax and morphology). And, because in a language like English the alphabetic letters correspond quite well to the various speech sounds, modern linguists in the West have failed

(until quite recently) to notice the role that graphic signs and speech sounds, in their interface with meaning, play in the ever-changing phenomena of words. Linguists, sometimes even more so than most people, can remain bogged down in our dictionaries—the more prestigious, the more dangerous—which become the stifling voice of authority. This has never been so in China, where what Western linguists now call "morpho-semantics"—the study of the coalescence of meaning and form—has always played a central role in the study of language. It is not difficult to prove that meaning is not the exclusive preserve of language, as it plays an equally important role in music, graphic art, three-dimensional art, religion, mores, in short, in the whole of our culture.

Furthermore, meaning is intersubjective. Provided we share a common language (often the bridge between different cultures), this intersubjective domain of meaning becomes the embodiment of communication, and we are able—through words and grammar—to negotiate messages, establish and maintain communal and personal bonds, influence others, empathize more effectively with others, and so on. But even if we do not share a common language, we can still communicate. Signs, gestures, and drawings can often do just as well as speech. This is because meaning is universal and not confined to a group of people.

Western languages, over the last three thousand years, have used only alphabetic writing. This has resulted in an increasing neglect of the wholeness and integrity of words—words are truly works of art in a microcosm—and an eventual failure to take into account the close-knit relations between the use of language and other expressions of art and culture. This has not happened in China, because the relationship between meaning and form stares you in the face.

When you write a Chinese character, you are writing both a meaning (for example "sun" and "moon") and a form. Later, it became possible to include a phonetic radical inside the character, which would generate words that included rhyming clues to their pronunciation and, at the same time, introduced a high degree of economy into the writing system. One did not, in other words, need a separate character for each separate meaning. It is not surprising therefore that the sense of meaning within a word (i.e., character) should have remained integral. In contrast, in the West,

we have lapsed into a confusion of meaning and reference, a problem that has never troubled the Chinese, but which has exercised modern Western philosophy ad nauseam. Again, this is not surprising, since all the reader sees in a word is a jumble of letters, which in most cases do not seem to relate to any other such jumbles in the language. Research, however, has been looking into this aspect of language, trying to find patterns in the jumbles and subcategories of meaning that interface with these patterns.

A point hammered home by contemporary French philosopher Jacques Derrida is that writing—or what he has called the trace—is the beginning of everything. Modern scholars and scientists, again especially in the West, tend to assume that writing is a relatively modern invention, unlikely to be older than about 5,000 years. But then it depends on what is understood by writing. If writing is taken to mean a graphic representation of what is spoken, then that time scale would be valid. But if the origins of writing stretch back into a distant mythological past, an idea that not a few are now coming around to, then we should expect to find the cave-painted or rock-carved incisio—an arrangement of strokes—to engender a meaning. Only then would we find ourselves nearer to the origins of writing and ourselves as human beings. Our remote Palaeolithic ancestors were not individual selves as yet, but their lives resounded to the song of nature, to the rhythms of all art, and to the visions and symbols of the dreaming. The cave paintings of the Dordogne, Pyrenees, and Northern Spain, though among the finest pictorial representations of all time, are not just pictures. They are what André Leroi-Gourhan believed to be "mythograms," arranged, as they are, not randomly but in a certain abstractly narrative order, like the hexagram components of the I Ching. They would have been read—that is, interpreted—probably at certain seasons and during the manifestation of portents, like comets or auroras. They could well have served, as apparently such graphic designs (in their earliest forms these could be some 60,000 years older than the cave paintings in Lascaux) once did among the Australian Aboriginals, as the basis for epic narratives.

Meaning, whether in poetry, music, drama, dance, painting, sculpture, sacred rituals, or in whatever, is a mysterious unconscious source that

never dries up. It perpetually wells up in the form of symbols.

A symbol is not something that can be readily explained. It is not just a representation, as for instance a red cross on an appropriate background signifies the presence of medical and other assistance, or a skull-and-crossbones sign spells danger. A symbol is ineffably more than that. I say "ineffable" because no amount of word use can exhaust its potential. It was Ernst Cassirer who claimed that human beings are neither specifically tool-users, however innovative, nor even talking animals, however creative, but generators of symbols. Every creative human act is the realization of this symbol-generation, even though for us moderns this power is concealed in the depths of the unconscious. Symbols are simple things in themselves, but they lie beyond ordinary experience and comprehension; they are—to use a trendy revived word—transcendental, having nothing in common with symbols as understood in logic and analytical philosophy. A symbol can be embodied in a lake, a mountain, an eagle, a mandala, or a birdsong. But it is no mere extra, a factor added to our experience. Symbols break through the everyday phenomena and render our reality intelligible. A symbol can invest a visual image, a musical cadence, a sculpted figure or relief, a texture, an atmosphere, a mood, a relationship (most notably a first love), a nightmarish occurrence, quite arbitrarily, or so it might seem.

Calligraphy is perhaps the most fundamental of all arts, preserved only in cultures in which graphic and linguistic expression remain distinct, yet not separable, as in China and the Chinese-influenced cultures of the Far East. In cave art, as in calligraphy proper, the movement of a brushstroke (or whatever other implement may have been used) is the beginning of all art, preceding the application of paint or ink to a surface, the throwing of clay, the shaping of a cross-rhythm or cross-harmony of a musical phrase.

No wonder then that calligraphy holds pride of place in China. Calligraphy is not solely the writing of existing words, not just an embellishment of existing graphism. Fung Ming-chip, one of the contributors to this exhibition, has said: "When there's the first brushstroke on the paper, then there's some kind of space relationship between brush movement and space. As the second brush stroke was finished, the space between the two strokes was made. When the first word was done, the space within the word (interior space) and the surrounding of the word (exterior space) was created." This is a unique, but primal "management of space"; it is a rhythm, a captured nuance of meaning and feeling, in itself almost a new life creation. The new symbolic potentialities behind familiar words taunt the calligrapher with their epiphanic gaze.

The fresh approaches to art in our own day recognize the symbolic, hence cultural, power inherent in the graphic word, and its significance in shaping the imaginative range and perceptual sensibility of the Chinese mind. Completely new in this exhibition are the effects of their interaction with Western norms. We find here also the narrative deconstruction of Post-Modernism, the fun-poking at the dead-hand pedantry of lexicographic power: 'That's a misprint!' 'What character is that supposed to be?' 'That character is pure invention!' 'How can a Chinese think of writing something like that!' But not everything among these artworks is logographic (i.e. word and graph) interplay. Inevitably, there is a serious, one might say political note. An entire historical tradition is playfully, not destructively, under review. The logographic art of China cannot be undermined, but it needs to respond to the new millennium. This exhibition is just the beginning.

Robert Lord is a graduate of Oxford University and for many years, was Chair Professor of Applied Linguistics at the University of Hong Kong. He was also Dean of Arts and Professor of Language and Humanities at Hong Kong Baptist University. While living in Hong Kong, he developed a strong interest in Chinese writing, art and culture and has published many academic papers on linguistics, lexicology, and language issues in the community. He is also a musician of some standing and has become interested in the relationship between music and meaning. He now resides in Cambridge, England.

For the dimensions given, height precedes width precedes depth. Works illustrated in the catalogue are marked with an asterisk.

FUNG MING-CHIP

CALLIGRAPHY

Each Other (Music Script), 1998
Ink on rice paper mounted on scroll
55 1/2 x 27 1/2 inches

Night (Scattered Code Script), 1997
Ink on rice paper mounted on scroll
54 3/4 x 14 inches

*Song of the Night Walker
(Light Ink Time Script)*, 1997
Ink on rice paper mounted on scroll
55 1/4 x 14 inches

Accidentally Passing (Form Script), 1997
Ink on rice paper mounted on scroll
74 3/4 x 26 3/4 inches
104 3/8 x 28 inches (with scroll mount)

*Buddhist Heart Sutra (Light Script and
Transparent Script Couplet)*, 1997*
Ink on rice paper mounted on scroll
Two scrolls: 27 5/8 x 27 5/8 inches each

SEALS

Book of Seals, 1975–1985
Accordion book with nine impressions of
hand-stamped stone seals with translations.
Dimensions variable: 6 x 4 inches each page,
6 x 69 inches fully opened

Seals, 1975–1985
Hand-carved stone seals from above book
Four seals: Dimensions variable (average under
two inches each)

WOOD RELIEF CARVINGS

*The More You Hide, The More You Are
Exposed*, 1990
Acrylic on wood relief
Irregular: Approximately 30 x 10 x 1 1/4 inches

Thunder Bright, 1990
Acrylic on wood relief
Irregular: Approximately 36 x 24 x 1 1/4 inches

Four Seasons, 1985*
Acrylic on wood relief
Four panels: 48 x 12 x 1 1/4 inches each

Untitled, 1998
Pigment on wood relief
11 1/2 x 36 x 1 1/4 inches

Untitled, 1998
Pigment on wood relief
11 1/2 x 36 x 1 1/4 inches

Untitled, 1998
Pigment on wood relief
11 1/2 x 36 x 1 1/4 inches

Untitled, 1998
Pigment on wood relief
11 1/2 x 36 x 1 1/4 inches

Untitled, 1998
Pigment on wood relief
11 1/2 x 72 x 1 1/4 inches

SCULPTURES

Three Generations, 1992
Bronze
9 1/2 x 14 1/2 x 4 3/4 inches

Command of Wind and Rain, 1992*
Bronze
34 3/8 x 31 1/4 x 5 1/4 inches

In Seclusion, 1992
Bronze
8 x 8 x 2 3/4 inches

Eternity of the Fifth Kind, 1992
Bronze
18 x 29 x 7 1/2 inches

GU WENDA

*The Modern Meaning of Totem
and Taboo*, 1986*
Ink and watercolor on paper
Triptych: 113 5/8 x 71 1/4 inches each

Mythos of Lost Dynasties, 1986–1995*
From the Sky Dynasty series
Total of nine scrolls 132 x 60 inches each

The Praying Wall, 1993–1997*
From the United Nations 2000 series
Human hair and white glue; Twenty panels
78 x 48 inches each
(installation dimensions variable)
(Four panels: Sanskrit; four panels: Chinese;
four panels: English; four panels: Arabic;
four panels: mixed scripts)

Enigma of Birth, 1993–1998
Four cast-metal beds with mattresses
covered with glass boxes: approx. 20 x 20 x 50
inches each
Three bags containing powdered human
placenta labeled "normal," "abnormal,"
and "stillborn"

HUNG TUNG

Signature of Hung Tung, approximately 1977
Ink and gouache on paper
17 3/8 x 10 3/8 inches unframed
30 3/4 x 24 3/4 inches framed

Couplet, 1977*
Ink and gouache on paper
mounted on scroll
(a) 68 3/8 x 17 3/8 inches
(b) 69 1/4 x 17 5/8 inches

Calligraphy (HT-85), approximately 1976
Ink on paper mounted on scroll
66 1/4 x 17 1/4 inches

Untitled (HT-47), 1974
Ink on paper mounted on scroll
54 1/4 x 27 1/2 inches

Untitled (HT-112), approximately 1977
Ink and gouache on paper
54 3/8 x 27 5/8 inches

Phoenix Boat, approximately 1977
Ink and gouache on paper
11 3/8 x 28 3/8 inches (unframed)
23 1/4 x 48 1/2 inches (framed)

Helu!!, approximately 1980
Ink and gouache on paper
31 3/8 x 21 3/4 inches

Butterfly God, c. 1976*
Ink and gouache on paper
mounted on scroll
70 3/4 x 33 1/8 inches

King, approximately 1977
Ink and gouache on paper
mounted on scroll
54 3/8 x 27 1/8 inches

Untitled (HT-53), approximately 1975*
Gouache on fiber board
16 3/8 x 24 1/2 inches (unframed)
27 1/4 x 41 1/2 inches (framed)

KING OF KOWLOON
(TSANG TSOU-CHOI)

Untitled, 1998
Ink on metal utility box
60 1/2 x 32 x 18 inches

Untitled, 1998
Ink on metal utility box
60 1/2 x 32 x 18 inches

Untitled, 1996–1998*
Photographic installation of seventeen
photographs that document the utility boxes
in-situ. The photographs are of various sizes;
four photographs: 26 x 19 1/2 inches each by
Liu shang-yang; six photographs: 12 x 19
inches each by Simon Wu; seven photographs:
25 x 35 1/2 inches each by Eric Otto Wear

Untitled (Panegyric Plaques), 1998
Gray sandstone with panegyric text
in brush-writing
Nine plaques: 19 1/4 x 19 1/4 inches each

Untitled (Calligraphy Panels), 1999
Ink on colored cloth
Seven panels: 94 x 30 inches each

MAO ZEDONG

Ode to the Plum Blossom, (Poem dated
1961, calligraphy undated)*
Ink on paper mounted on scroll
16 3/8 x 33 3/8 inches
20 x 59 1/8 inches (including scroll mount)

The Long March, (Poem dated 1935,
calligraphy undated)
Ink on paper mounted on scroll
20 5/8 x 59 1/8 inches (including scroll mount)

Changsha, (Poem dated 1925,
calligraphy undated)
Ink on paper mounted on scroll
20 5/8 x 65 1/8 inches (including scroll mount)

Struggle, n. d.
Ink on paper mounted on scroll
64 x 22 inches (including scroll mount)

*"Being lucid in worldly knowledge is a form
of scholarship; being worldly wise in human
affairs is a kind of literature,"* n. d.
Ink on paper mounted on scroll
53 3/8 x 20 inches (including scroll mount)

*(all exhibits of Mao Zedong's calligraphy
are facsimili reproductions)*

QIU ZHIJIE

*Copying One Thousand Times "Preface to
Orchid Pavilion Anthology,"* 1995–1996*
Mixed media installation:
Ink on paper: 27 x 62 1/2 inches
Nine photographs: 12 x 15 inches each;
four photographs: 15 x 10 1/4 inches each,
documenting the progression of the work.

8th of April, 1996*
Mixed media installation:
Four sheets of paper: 100 x 72 inches each
Four original newspapers: 31 1/8 x 21 5/8
inches each
Four framed curriculum vitas
(three for each transcriber and one blank):
12 1/4 x 8 inches each
Four metal panels with brass plate insets:
28 1/4 x 42 1/8 inches each

The Nine Court Square, 1998
Nine VCRs, nine monitors and nine videotapes
Video installation: 45 x 160 x 160 inches overall

Heart Sutra
Mixed media installation including an animal
heart in preservative, twenty cloth panels with
writing, visible when illuminated by black light
Text of the writing is the Buddhist Heart Sutra
Dimensions variable

WANG YONGMING

Five-Stroke Character Code, 1987*
Two computers on tables; Two sets of instructions
Dimensions variable

WU SHANZHUAN

*Smoking is Prohibited in the
Parking Area,* 1987*
From the Small-Character Posters series
Ink and red gouache on paper
53 x 159 1/2 inches

Hu Shuo Ba Dao, 1987*
From the Small Character Posters series
Ink and red gouache on paper
Four panels: 54 x 53 5/8 inches each
108 x 108 inches overall

Red Seal, 1986*
From the Red Seals series
Oil on canvas
78 x 78 inches

Lao Wang I've Gone Home, 1986
Oil on canvas
36 x 36 inches

Leave Your Message Here, 1986
Oil on canvas
36 x 36 inches

Cabbage 3 Cents a Catty, 1985
From the 75% Red, 20% Black,
5% White series
Oil on canvas
72 x 72 inches

Garbage Nirvana, 1985*
From the 75% Red, 20% Black,
5% White series
Oil on canvas
58 1/2 x 77 3/4 inches

No Water This Afternoon, 1985–1997
From the No Water This Afternoon series
Based on original manuscript of a novel
with illustrations
Color and lead pencil on paper encased
in a plexiglas box: 4 1/4 x 14 1/2 x 19 1/2 inches

XU BING

Clay Words, 1993
Mixed media installation:
Thirty-six clay seals: 6 1/4 x 3 x 3 inches each
Overall dimensions variable

Square Word Calligraphy, 1996*
Mixed media installation: VCR, monitor, and
videotape; Chalk board; Three sets of desks and
chairs and chairs; Three calligraphy ink and
brush sets; 200 copy books; Eleven framed
copies of student's work: 23 1/2 x 29 1/4 inches
each; Six framed instructional diagrams:
18 x 24 inches (4); 25 x 33 inches (2); Five
practice copy books; Twenty-five photocopy
sheets from copy books; Two classroom sign
boards, painted green

Notes, 1993–1994*
Thirteen sheets of paper, including artist's
research for *Square Word Calligraphy*

Book From the Sky, 1989*
Four thread-bound woodblock printed books in
a wood bookcase
Ink on paper
18 x 12 inches each book